THE
MARKER PLAYBOOK

44 Simple Exercises to Draw, Design
and Dazzle with Your Marker

ANA MONTIEL

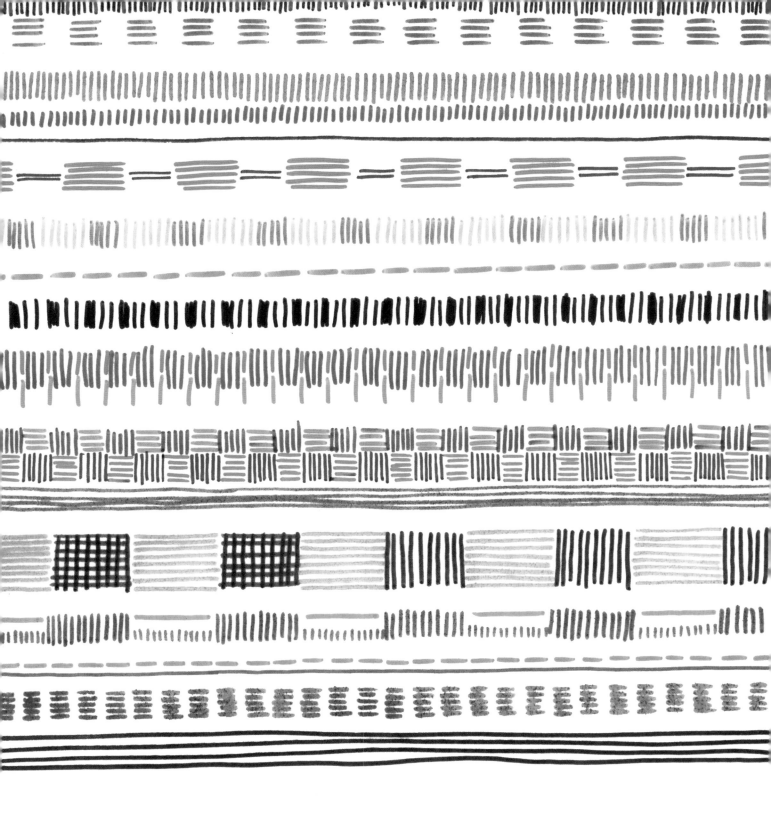

"SERIOUS ART IS BORN FROM SERIOUS PLAY." JULIA CAMERON

CONTENTS

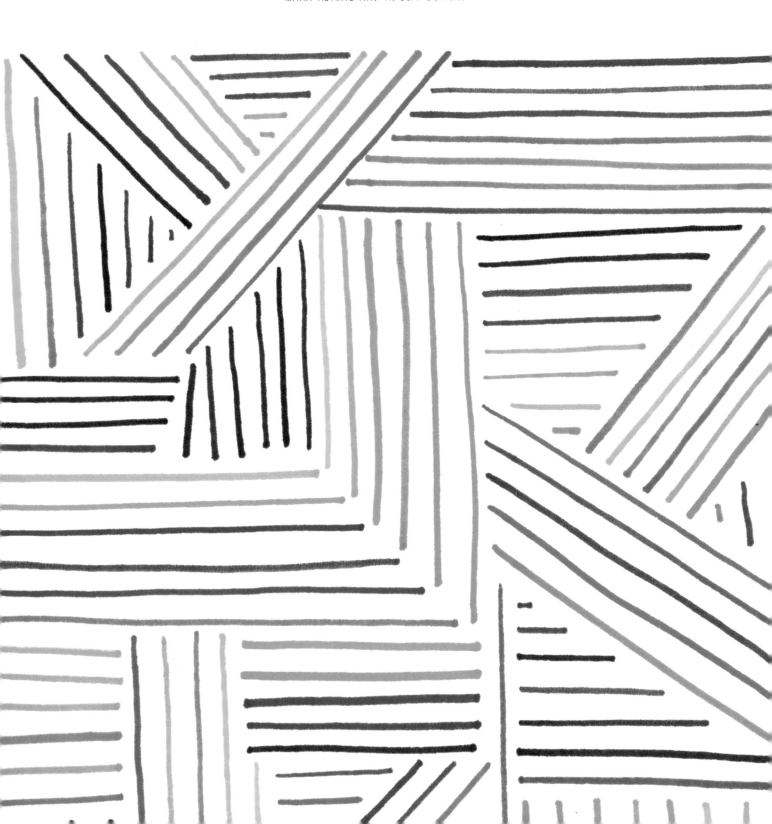

Thank you for choosing this book. I'm very happy to have you here.

Inside this playbook, you'll find exercises for exploring various marker techniques. I provide instructions and tips, but feel free to experiment in different ways and follow your intuition. The key is to have fun with our markers!

The artwork doesn't have to look great all the time, nor does it have to be too detailed or representational. What matters is enjoying the creative process and taking incremental steps toward a more colorful life. Creativity has to be free and never is to be judged. Everything has a place in this world, even the things you consider ugly may seem beautiful to another person!

Sketching and experimenting with markers can be the kind of activity that helps you focus on the present moment and allows you to tap into your inner wisdom to find some insight. For me, they are like meditating. When we turn off our rational brain for a while, we can start getting in touch with our wildly creative subconscious mind. This is one of the powers of art.

Be inspired, play, draw—make a mess if you may—clean and repeat. Forever.

Yours in color and shape,

Ana Montiel

COLOR CHART

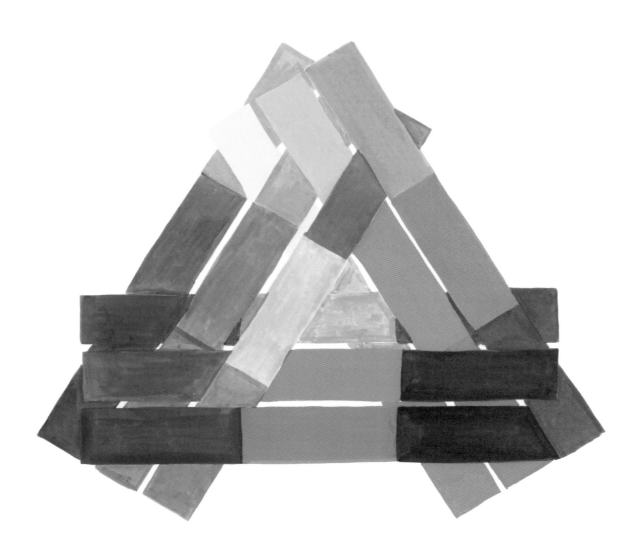

DRAW HERE

There are many ways to organize and arrange colors. The key to this exercise is to find the order that works best for you. Rainbow gradients? Light to dark? Muted and bright? Choose a shape that you like, such as a prism, rectangle, or other shape, and divide it into many areas. Start filling the areas with colors to become familiar with your palette.

TIP: YOU CAN MAKE YOUR COLOR PALETTE MORE COMPLEX BY OVERLAPPING THE COLOR SWATCHES. DO THIS BY LAYERING ONE OR MORE COLORS ON TOP OF ONE ANOTHER.

RAINBOW NET

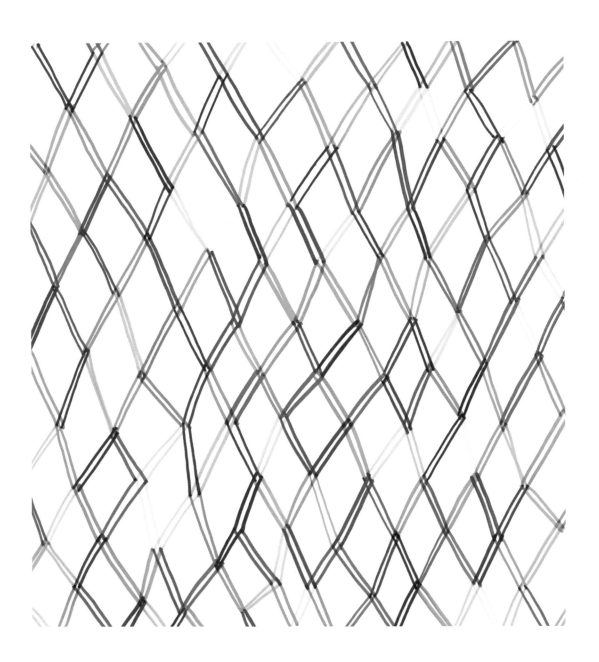

DRAW HERE

Patterns don't need to be super complex. In fact, you can create them from the simplest things. Choose a simple shape and draw it freehand over and over again. You can change color each time or use a monochromatic palette. Don't judge—just enjoy the process. Repetitive drawing can be a powerful meditative experience.

TIP: COMPOSITIONS MADE OF 90- AND 180-DEGREE ANGLES, SUCH AS CROSSWORD PUZZLES, LOOK STATIC. AVOID THEM AND ROTATE YOUR SHAPES IN DIFFERENT WAYS IF YOU WANT YOUR ARTWORK TO BE MORE DYNAMIC.

BOLD CONSTRUCTIONS

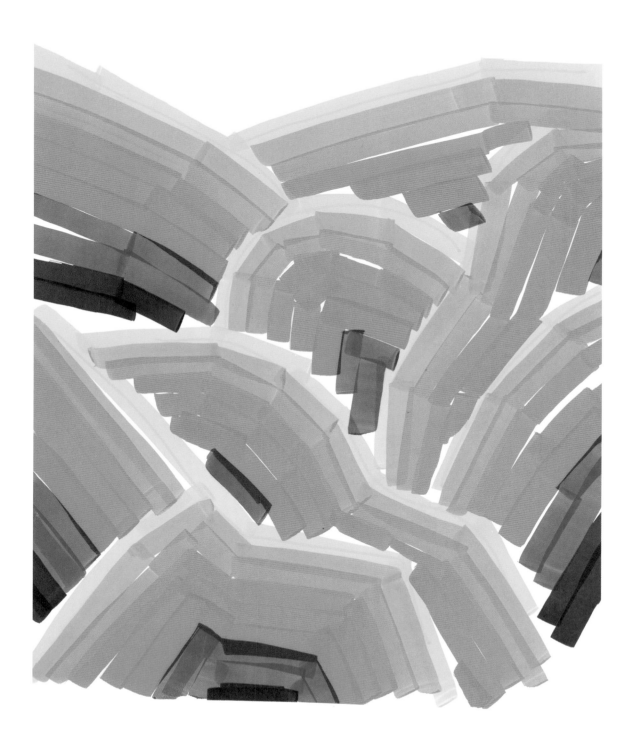

Connect with your inner child and start making random marks above or on another piece of paper. The marks can be bold and wild or tiny and delicate for a more textured look. Have fun and don't be afraid to make a mess. Sometimes messy is fun!

TIP: YOU CAN MAKE MANY MARKS IN DIFFERENT PLACES WHENEVER YOU PICK A NEW COLOR. THIS WAY, YOUR PROCESS WILL HAVE FEWER INTERRUPTIONS AND BE MORE FLUID AS YOU SWITCH FROM COLOR TO COLOR.

OVERNIGHT MARKERS

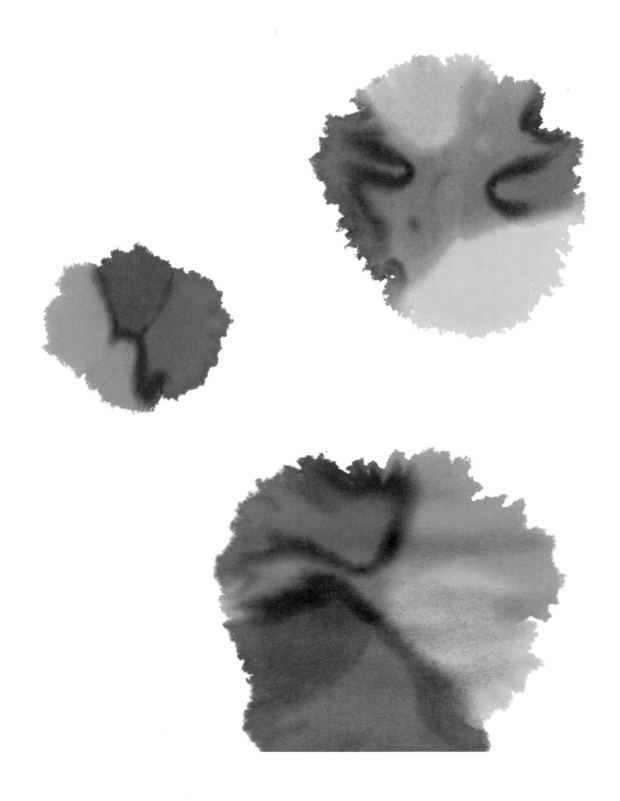

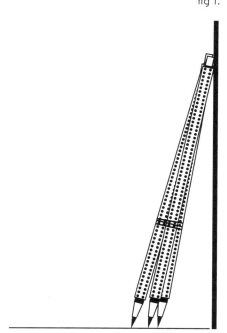

fig 1.

Choose a group of markers that you like and that blend well and tie them together with a rubber band or string. Remove the caps, place the marker bunch with the tips touching a piece of paper and lean them against a wall (see fig 1 above). Be sure that the tips of all the markers are touching the paper and let them sit overnight. You'll be able to see the rainbowish results in the morning!

TIP: DON'T USE FANCY MARKERS FOR THIS EXERCISE. THE TYPICAL FELT-TIP ONES WORK GREAT ON TOP OF POROUS, NONGLOSSY PAPER. USE HEAVYWEIGHT PAPER SO THAT IT STAYS FLAT.

DIY STAMPS

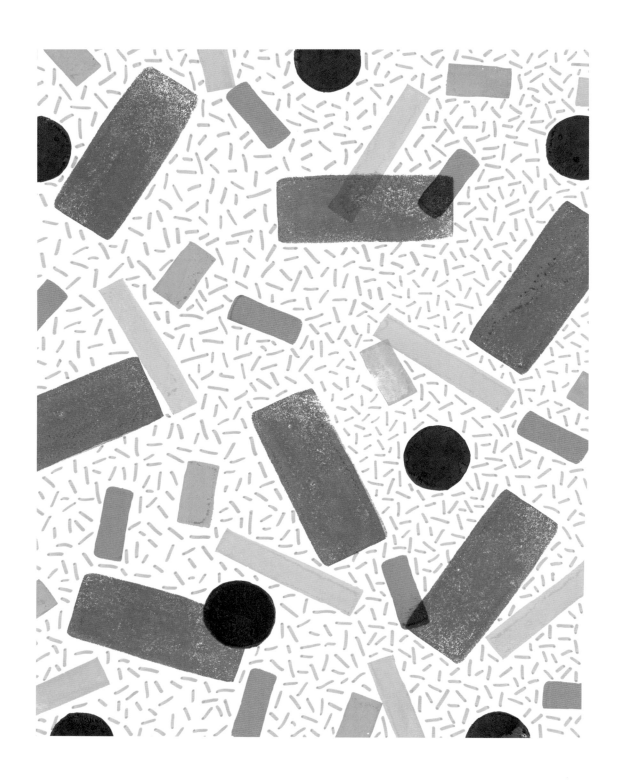

DRAW HERE

To make DIY stamps, cut and/or carve erasers with a craft knife or with engraving tools, if you have them. Paint the surfaces you want to use as stamps with markers of your choice and carefully place them on top of the paper. Repeat the coloring/placing process as needed to create a pattern or composition and have fun!

TIP: ONE OF THE BEST THINGS ABOUT USING MARKERS TO INK YOUR STAMPS IS THAT YOU CAN APPLY ALL THE COLOR GRADIENTS AND MOTIFS THAT YOU WANT. THEY DON'T NEED TO BE A SOLID COLOR! TRY IT AND SEE.

MAKING UP ANIMALS

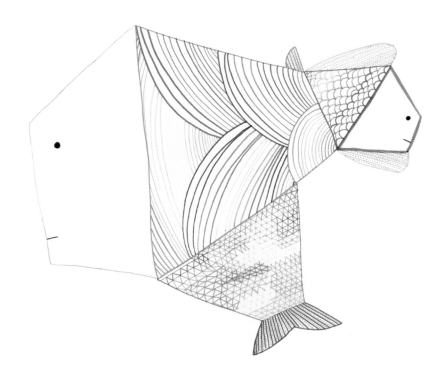

DRAW
HERE

For this experiment, try inventing animals of your own. They can be similar to ones that already exist or you can dive into the unknown and come up with something totally new. Let go of preconceptions. Two heads, why not? Let your inner child play!

TIP: EXPLORE LINE AND TEXTURE FOR THIS EXERCISE. VIEW A FEW ANIMAL CLOSE-UPS ONLINE TO SEE THEIR AMAZING SKIN PATTERNS AND TRY MAKING UP NEW ONES. THEY CAN BE AS SIMPLE OR AS COMPLICATED AS YOU WISH.

FILLING A GRID

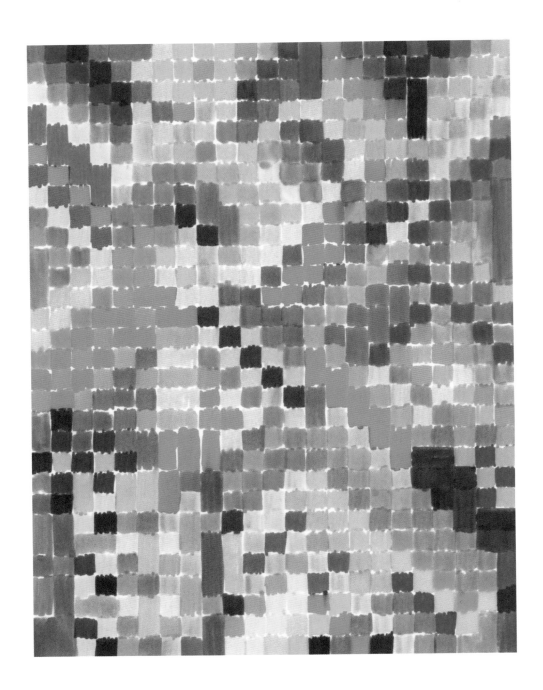

Let's play with a composition of pure colors gathering inside a grid. The structure I used for this exercise is made of squares but you could make your own with circles, triangles, or any other shape. On www.printablepaper.net you can generate, download, and print all kinds of grids if you want to take it further and keep experimenting.

TIP: BE MINDFUL OF COLOR WHEN FILLING THE GRID. IF YOU WANT A COMPOSITION WITH STRONG IMPACT, PLAY WITH COMPLEMENTARY HUES. FOR A MORE SUBDUED LOOK, NARROW YOUR RANGE TO A WARM PALETTE.

MONOTYPING

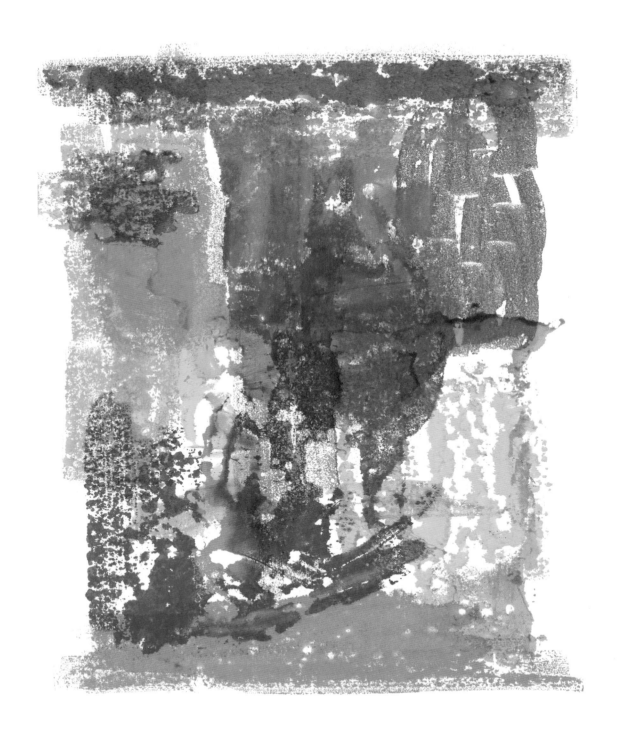

DRAW HERE

Monotyping is one of the easiest printmaking techniques. To try it, you just need a non-absorbent surface, such as acetate. Draw on top of it and then press it onto a sheet of absorbent paper or above. The key here is to be quick when applying the color so it's as fresh as possible. Wipe the acetate with a tissue between colors to keep your print clean.

TIP: YOU CAN USE A PIECE OF ACETATE AS A MIXING PALETTE. OVERLAP MARKERS OF DIFFERENT COLORS TO ACHIEVE AN OMBRÉ OR MULTICOLOR LOOK. ALWAYS START WITH THE LIGHTER HUE TO KEEP THE MIX FRESH LOOKING.

FAVORITE FRUITS

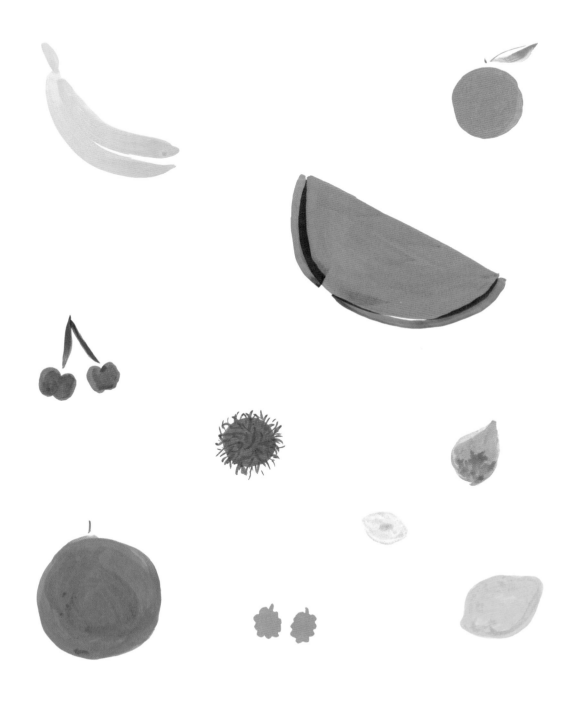

DRAW HERE

Think of your favorite fruits or vegetables for a moment. Consider what makes them recognizable. Is it the color? The shape? The size? Play with these ideas and draw them as detailed or as simple as you wish. Often a couple of strokes are more than enough to communicate an idea or represent an object.

TIP: IF YOU WANT TO MAKE THE SOLID COLOR SURFACES EVEN, APPLY A BLENDER MARKER TO THE AREA JUST BEFORE COLORING. IT WILL SMOOTH AND EVEN OUT YOUR STROKES.

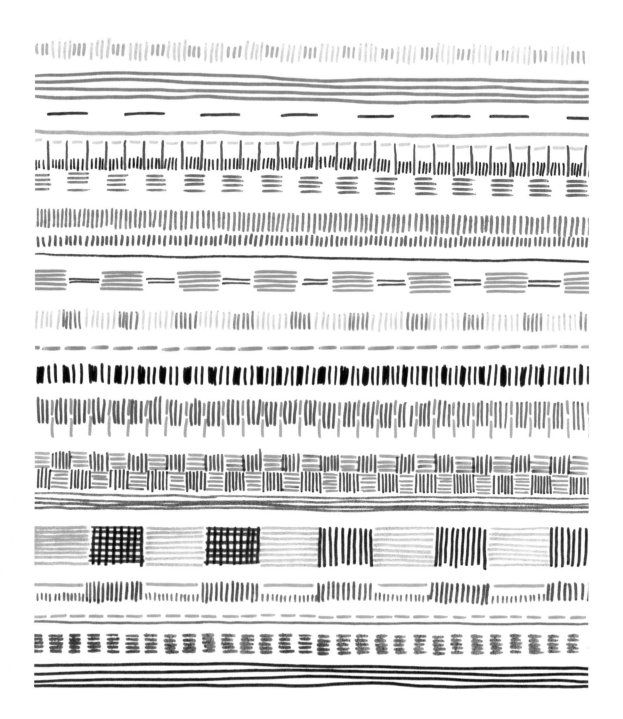

DRAW HERE

Let's make a pattern out of lines and bands. Create a rhythm out of something simple, such as a dashed line, and play with its repetition. Imagine the artwork is an abstract music sheet. Feel free to work with just one or two colors so that you can focus on the shapes and their tempo. Play some upbeat music for inspiration.

TIP: I SEARCHED FOR A SIMPLE LOOK AND STAYED WITH HORIZONTAL AND VERTICAL LINES, BUT YOU CAN TRY DIFFERENT ANGLES, WIDTHS, AND SHAPES FOR YOUR BANDS SO THAT THEY LOOK MORE LIKE GARLANDS.

COLOR A B&W PHOTO

Choose a black and white picture that you like. It can be one that you took with your camera, one from a magazine, or whatever you prefer. Start coloring it with your markers and be as realistic or surrealistic as you want. Play with your marks and don't forget that it's totally okay to paint a sky green, for example. Art must be free!

TIP: FOR BETTER RESULTS, AVOID CHOOSING A HIGH CONTRAST OR VERY DARK IMAGE. INSTEAD, FIND ONE WITH PLENTY OF GRAYS SO THAT YOU CAN LAYER YOUR COLORS ON TOP OF THEM AND ACHIEVE MORE DETAIL.

COLLAGE

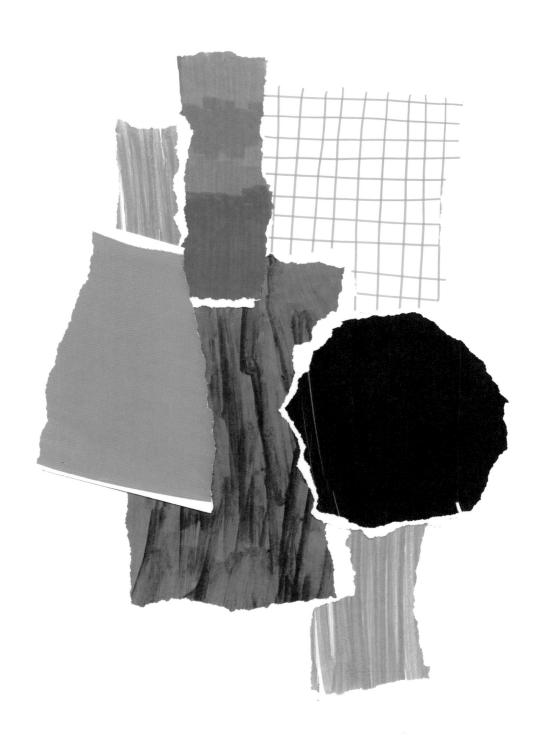

WORK HERE

This exercise is all about upcycling and reinventing. Find pieces of used paper, such as drawings and paintings that didn't turn out as you expected. Place them together, trying different compositions. When you are happy with the arrangement, glue the pieces to a sheet of paper or above. Have fun and don't think too much.

TIP: SCISSORS AND CRAFT KNIVES ARE A COLLAGE ARTIST'S BEST FRIENDS, BUT YOU DON'T ALWAYS NEED THEM. FOR A FRESH AND WILD STYLE, TEAR THE PAPER WITH YOUR HANDS AS I DID ON THE OPPOSITE PAGE!

3-D LETTER

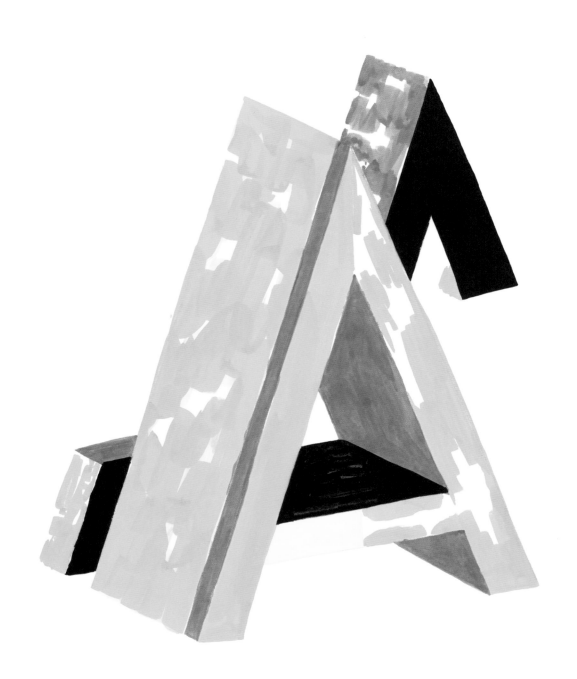

DRAW HERE

Draw the outline of a letter. Next, draw parallel lines of the same length in one of its sides or areas. (For example, draw a 45-degree angle line on one side.) Now join the lines by copying the shape of the letter. You'll outline the letter's projection this way. To make it more realistic, use darker shades on the inside or on one side of the letter.

TIP: IF A LETTER SEEMS TOO COMPLICATED, TRY A SIMPLE GEOMETRIC SHAPE. THE PROCESS IS THE SAME FOR BOTH. WHEN YOU BECOME MORE EXPERIENCED, DRAW THE SHADOW OF THE LETTER ON THE "FLOOR" FOR A MORE REALISTIC FINISH.

COLOR TESTS

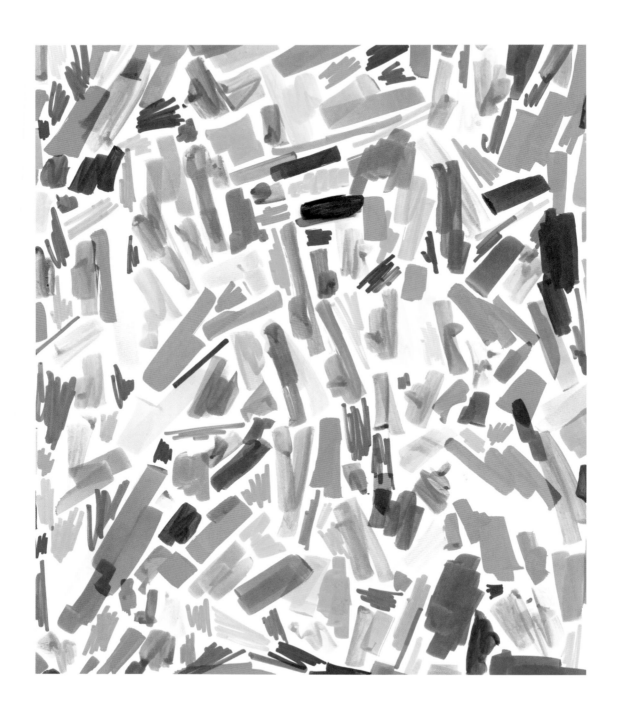

 DRAW HERE

There are two ways to do this exercise. One is to keep a sheet of paper by your side whenever you are drawing and make a mark on it anytime you switch colors. The other way is to make a color test sheet above just for fun and just for beauty. Picture it as a color party with all those different hues and shapes dancing around.

TIP: YOU WANT THE COMPOSITION TO BE DYNAMIC AND FRESH SO THAT IT LOOKS LIKE A TEST SHEET. USE DIFFERENT ANGLES AND WIDTHS. DON'T BE TOO CAREFUL WITH THE COMPOSITION. IT'S OKAY IF THE MARKS OVERLAP AT SOME POINT.

PLAYING WITH CONTRAST

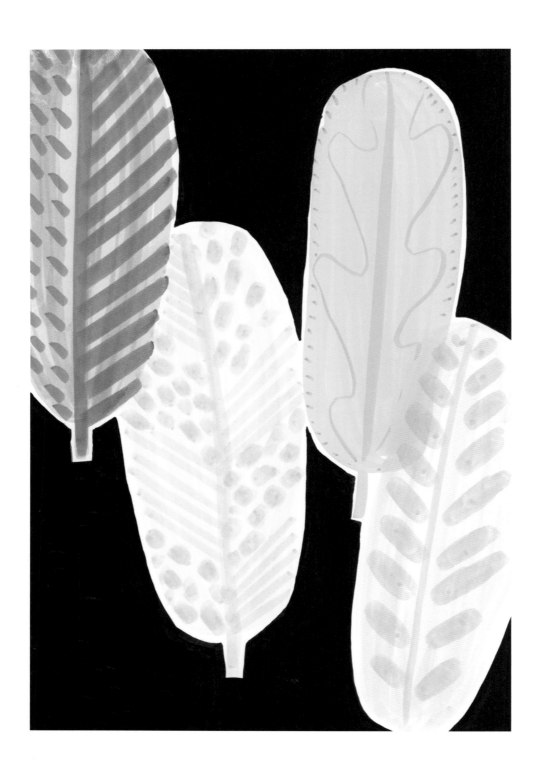

DRAW
HERE

Black gives strength to artwork that would otherwise be too pale or too subtle. There's nothing wrong with the latter, but contrast can be a bold and useful tool. Use pale markers to sketch something. Take a picture of it to remember how it looks and then color the background black or very dark. Compare the before and after and notice the change of personality of the same motif with just a different background.

TIP: IF YOU HAVE A SCANNER, I RECOMMEND SCANNING YOUR DRAWINGS AT DIFFERENT STAGES OF THE PROCESS. IT'S USEFUL TO CHECK EARLIER VERSIONS TO SEE WHAT WORKS WELL AND WHAT COULD BE DONE DIFFERENTLY IN THE FUTURE.

DIFFERENT CROPS

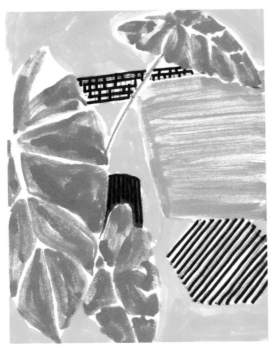
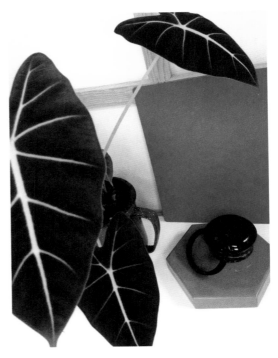
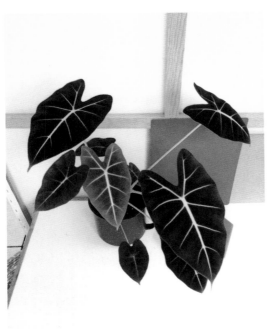
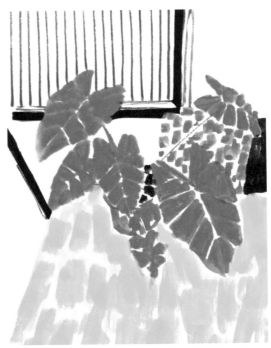

Create a still life with some objects. Take pictures of it from different angles. Don't be afraid of close-ups or aerial views because they can give you unexpected results. Make sketches of your favorite pictures with your markers. Notice how different the same scene can look depending on how close you are to it, your point of view, and so on.

TIP: FOR THE STILL LIFE, CHOOSE OBJECTS WITH DEFINED SHAPES SO THE COMPOSITION IS CLEAR. TO KEEP YOUR SKETCHES ACCURATE, OUTLINE THEM FIRST WITH PENCIL AND THEN ERASE THE MARKS WHEN THE ARTWORK IS FINISHED.

DRAW
HERE

This is a very simple exercise. Draw something but do not lift your marker from the paper during the whole process. To draw like this makes us go to places we would never go. In addition, the extra curves and strokes can give the artwork an interesting touch.

TIP: DRAW SLOWLY IN THE BEGINNING, THINK OF THE PATH YOU ARE GOING TO FOLLOW, AND DON'T FORGET THAT YOU CAN GO BACK AND RETRACE YOUR STEPS TO CREATE ADDITIONAL PATHS.

LAYERING COLORS

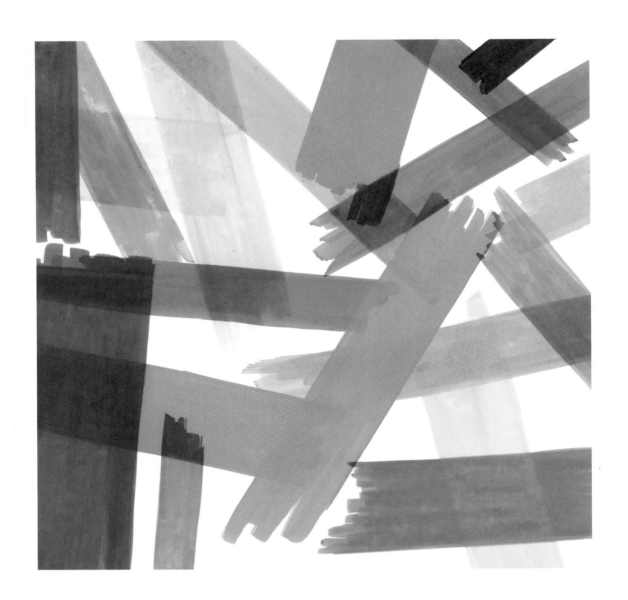

It's useful to know how your colors will look when you overlap them. Sometimes you can add several layers on top of each other to give more depth and complexity to certain areas. Be sure to use paper that is strong enough to handle so many marker strokes on top of one another.

TIP: START WITH THE LIGHTEST MARKER AND END WITH THE DARKEST ONE. THIS WAY, YOU'LL KEEP YOUR MARKER TIPS CLEAN AND THE COLORS WILL BE CRISPER.

SKETCHING MUSIC

"Wear Your Love Like Heaven" by Donovan

"Balance Her In Between Your Eyes" by Nicolas Jaar

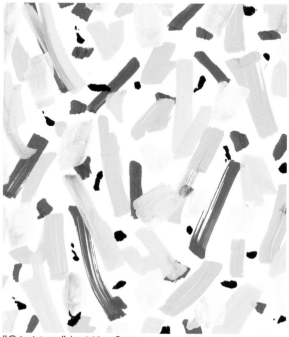

"Générique" by Miles Davis

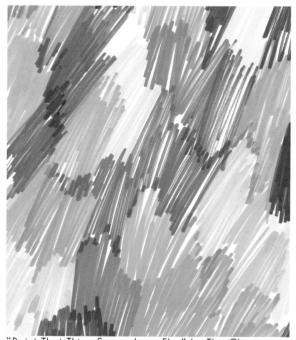

"Point That Thing Somewhere Else" by The Clean

DRAW HERE

Play a song that you love, close your eyes, and notice what images or colors come to your mind. Play the song a second time and start drawing as automatically as you can. Don't think, just go with the melody. You can go as representational or abstract as you want. Don't judge, just draw. Try different kinds of music and have fun!

TIP: SOMETIMES MUSIC CAN BE TOO ETHEREAL TO BE REPRESENTED IN A FIGURATIVE WAY, BUT THIS SHOULDN'T BE A PROBLEM. A SOLID COLOR OR SIMPLE SHAPE CAN COMMUNICATE MANY THINGS!

CRYSTAL FORMATIONS

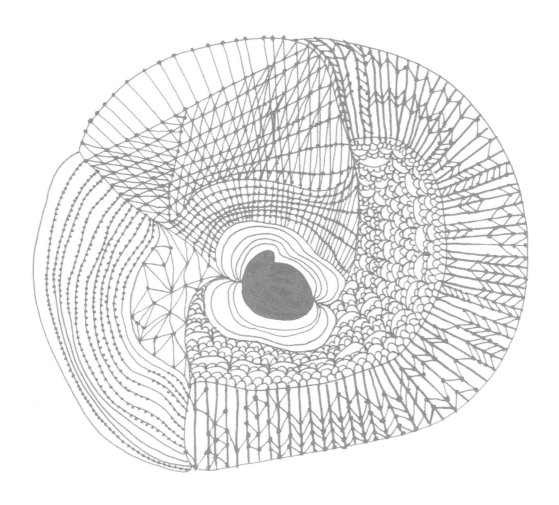

DRAW
HERE

Seeing the world up close is full of surprises. As soon as you start to look at something from a short distance, the wildest patterns, fractals, and textures appear. Look at some crystals, shells, or rocks and see which patterns you can spot. Now see whether if you can make up one of your own and apply textures to it that come to your mind and marker.

TIP: THINK OF THIS EXERCISE AS A ZEN MEDITATION. DRAWING TINY TEXTURES IN A MINDFUL WAY CAN BE ENJOYABLE AND THERAPEUTIC. BREATHE DEEPLY, FOCUS YOUR ATTENTION, AND STAY IN THE DRAWING AND THE MOMENT.

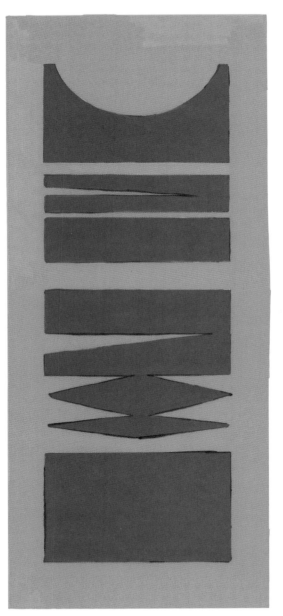
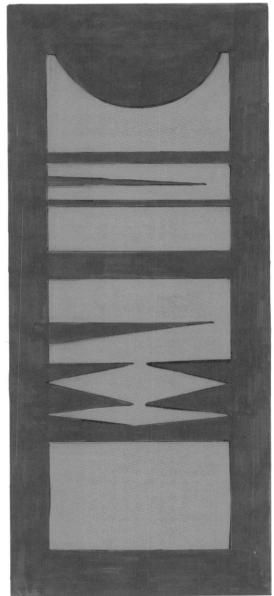

 DRAW HERE

Each color has its own personality and all behave differently depending on which hues are its neighbors, where it is placed, or the size of the surface it is inhabiting. Try this: Draw the same shape within a shape two times. Color the first one and color the second in the opposite way. Notice how balanced they can look together as a diptych.

TIP: FOR A BOLD LOOK, USE COMPLEMENTARY COLORS, SUCH AS RED AND GREEN. THESE TWO, WHEN PLACED TOGETHER, CREATE AN OPTICAL ILLUSION AND GIVE AN OP-ART VIBE.

CAMO PATTERNS

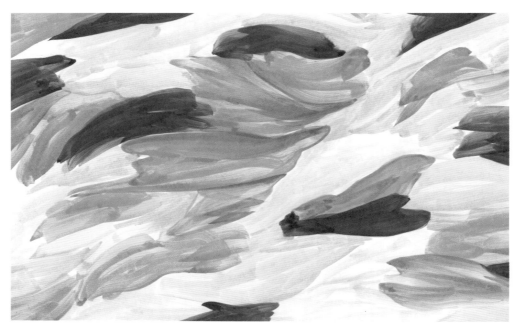

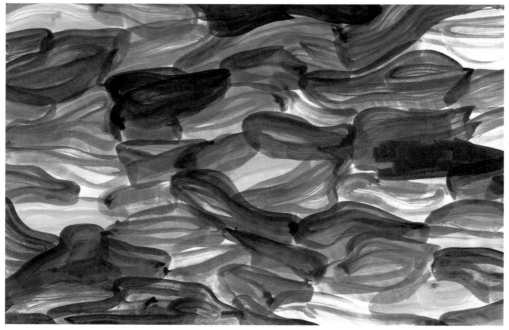

DRAW HERE

Camouflage patterns can vary a lot depending on where they are going to be used. To hide in a forest, you'll need green, ochre, and brown shades, but the palette can change a lot if you are going to the North Pole instead. Choose a place that you like, urban, rural or imaginary. Select a few colors from its color spectrum and start playing with abstraction above to create a pattern or texture that matches the environment.

TIP: THE SHAPES OF YOUR PATTERN CAN BE ORGANIC IF YOU WANT TO FIT IN AN ORGANIC ENVIRONMENT, BUT THEY CAN ALSO BE PRETTY SHARP IF THE LANDSCAPE HAS MORE STRAIGHT SHAPES THAN CURVES.

MASKING WITH FRISKET

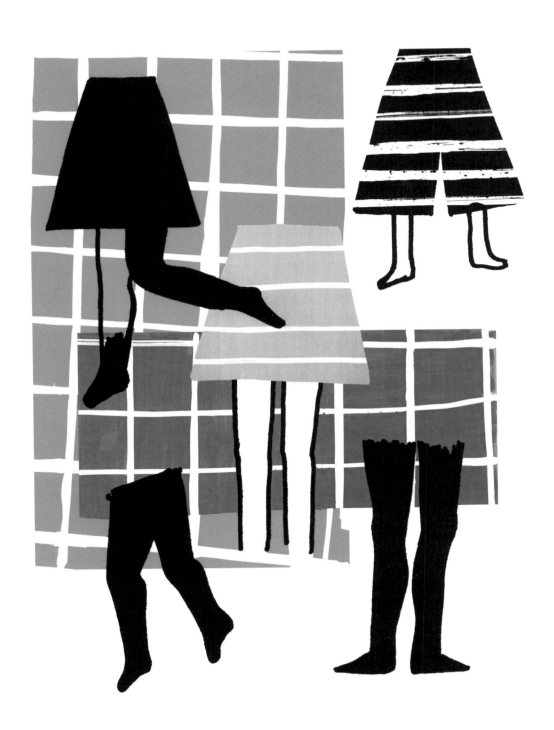

DRAW HERE

Frisket is a masking fluid or adhesive paper used typically in watercolor painting to block areas on the paper the artist doesn't want painted. It's useful when drawing with markers, too. Paint some grids with frisket on different papers. When the frisket is dry, cover the surface with your markers and remove the frisket, rubbing it with your clean fingers. Cut these papers into shapes and glue them on this page. You can add details with your markers on top of the collage!

TIP: GET FRISKET THAT IS WHITE OR TRANSPARENT. THE COLORED ONES CAN SOMETIMES TINT THE PAPER. TO APPLY THE FRISKET, USE AN OLD BRUSH THAT YOU DON'T USE ANYMORE. FRISKET TENDS TO RUIN BRUSHES WITH ITS STICKY TEXTURE.

SKETCH YOUR LUNCH

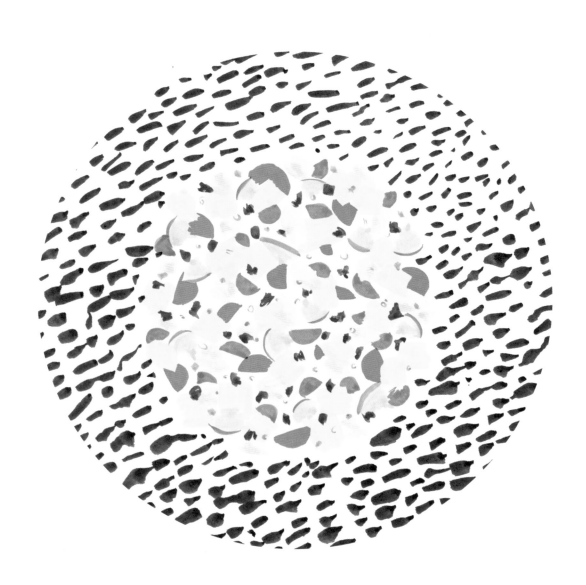

DRAW
HERE

You can represent your lunch as a detailed still life, as more of an icon, or just with a color. The important thing in this execise is to pay attention to your surroundings in a different way. Drawing helps us to understand things better and look at them differently. Notice the texture of a salad, the vibrant hue of beets—beauty is all around us!

TIP: TRY BRUSH MARKERS, SUCH AS ZIG CLEAN COLOR REAL BRUSH PENS, TO MAKE MORE EXPRESSIVE MARKS. THEY ARE A BIT PRICIER THAN OTHERS, BUT THE RESULTS YOU CAN GET WITH THIS KIND OF MARKER ARE PRETTY UNIQUE.

STIPPLING FOR DEPTH

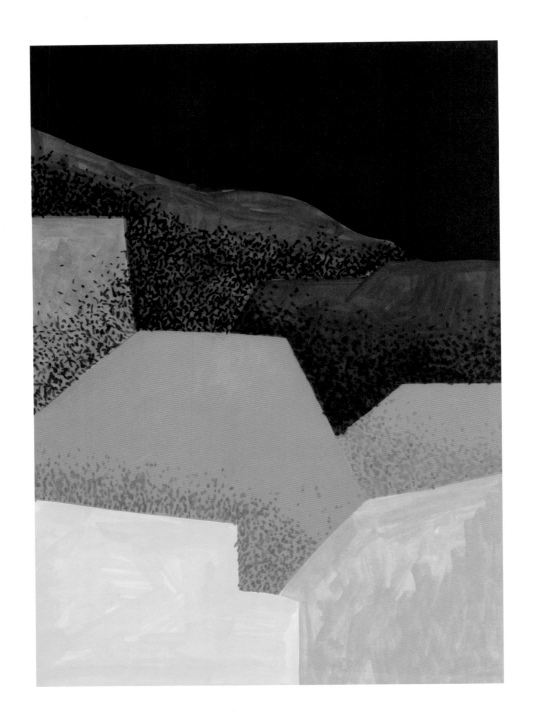

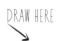

Stippling is a technique using dots to create a pattern that gives the illusion of depth or volume. It also can enrich the overall drawing, bringing extra texture to the party. Make a landscape, still life, or any other drawing and apply stippling around the borders of some areas. Use similar but slightly darker hues in the background to make it look natural.

TIP: YOU CAN ALSO USE COLORS TO PLAY WITH DEPTH AND HELP YOUR PERSPECTIVE WORK EVEN BETTER. THE HUMAN EYE NATURALLY PERCEIVES WARMER HUES AS CLOSER THAN COLDER SHADES, WHICH TEND TO RECEDE.

HALF-DROP ALLOVER PATTERN

1.

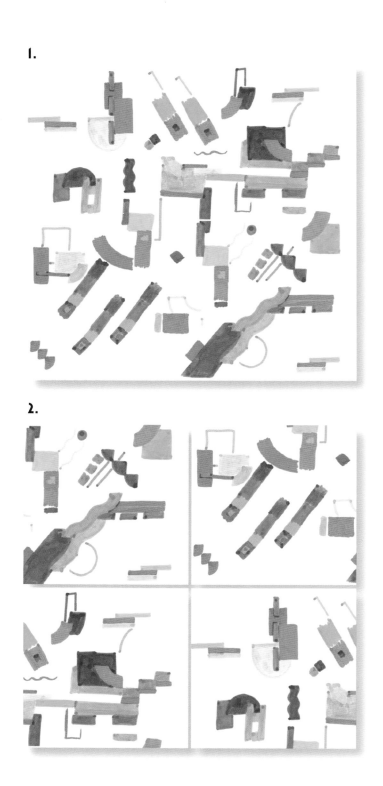

2.

3.

1. Create a drawing and leave a wide margin of blank space around it. Using a ruler, divide the paper into four equal parts. 2. Switch the positions of the four paper pieces. (The ones on the right move to the left and the ones on the bottom go to the top.) Join them by applying tape to the reverse side of the paper. To get a half-drop pattern, match one of the seams with the middle of the opposite paper. 3. Complete your drawing by filling in the blank areas and say hello to your repeat module!

TIP: FOR YOUR FIRST PATTERNS, YOU MAY WANT TO USE AN IMAGE EDITING SOFTWARE FOR THE REPEAT TO BE SEAMLESS. WITH PRACTICE, THE EDGES WILL LOOK CLEANER AND WON'T NEED RETOUCHING.

STROKES IN MOTION

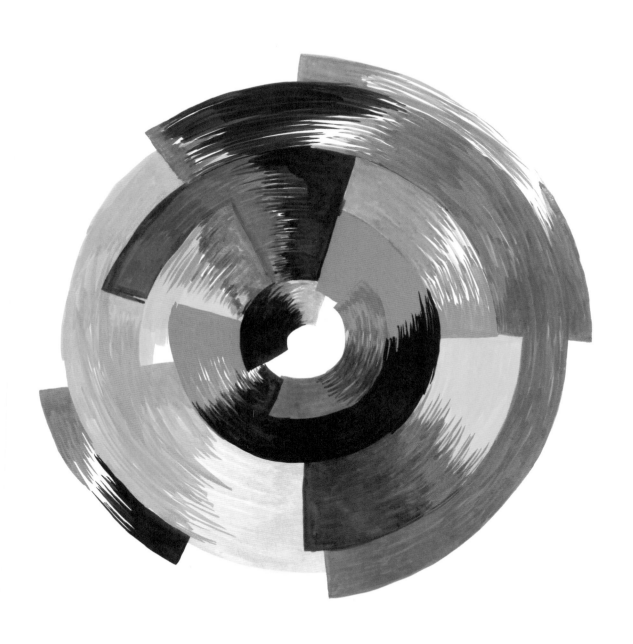

DRAW HERE

You can build the structure on the opposite page easily with the help of a compass and pencil. Then concentrate on filling the areas with different colors. Pay attention to the marks you are making while coloring. Be quick with your strokes and mindful of their pacing, the hues that you apply next to each other, and the direction of your strokes.

TIP: YOU CAN MAKE SOFT GRADIENTS—PINK TO RED, FOR EXAMPLE—BUT FEEL FREE TO TRY BOLDER COMBINATIONS FOR A MORE STRIKING RESULT. JUST REMEMBER TO GO FROM LIGHT TO DARK COLORS SO THE RESULT IS CLEAN-LOOKING.

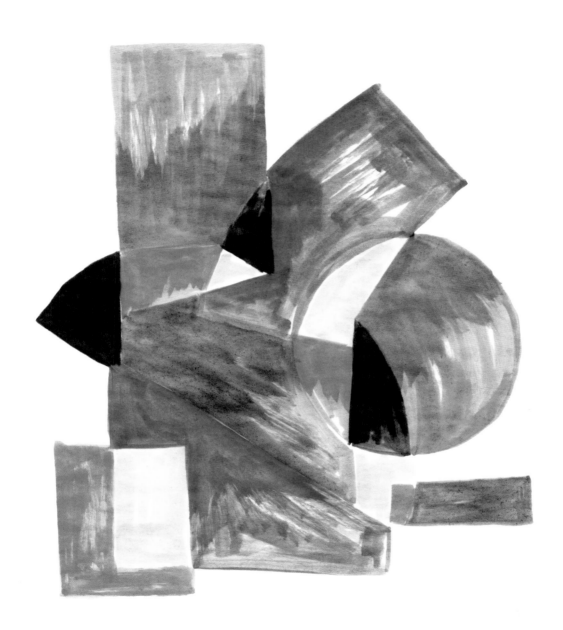

DRAW
HERE

Outline some simple shapes and notice their intersections. Where do they overlap? Their intersections create new shapes apart from the ones you already sketched. Highlight those areas when applying color for them to be fully revealed.

TIP: FEEL FREE TO TRY SHAPES OF ALL KINDS. THIS EXERCISE IS NOT ONLY FOR GEOMETRIC COMPOSITION. THINK OF A COUPLE KISSING, FOR EXAMPLE. THEIR NOSES OVERLAP AND THEIR COMBINED SHAPES CREATE A NEW SILHOUETTE.

WILD BLENDING.

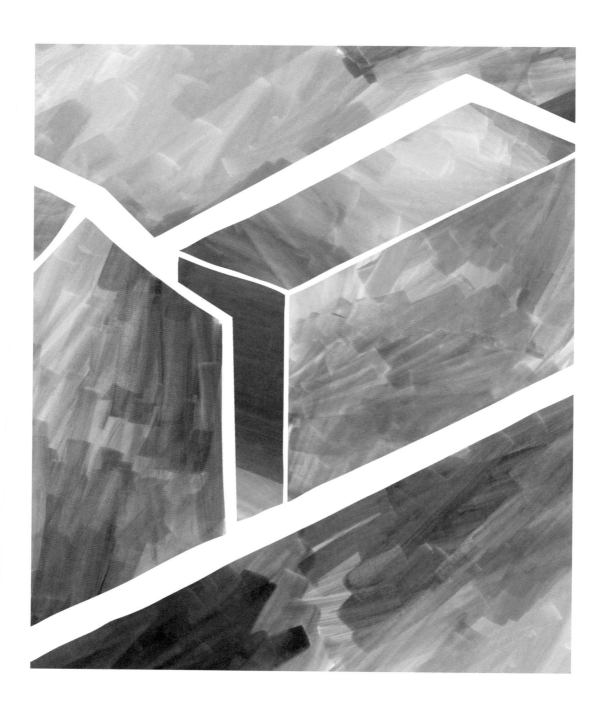

You can play a lot with blending if you have good markers and fast strokes. Apply different colors to different pieces of paper. Outline a composition above and cut the colored pieces of paper so that they look similar to the shapes of the composition. Arrange and glue the pieces to re-create the drawing with a collage.

TIP: APPLY THE COLORS QUICKLY, SO THAT YOU'LL BE ABLE TO ACHIEVE A MORE FLUID BLENDING. USE COATED PAPER TO PREVENT THE INK FROM SOAKING IN IMMEDIATELY AND THEREBY ALLOWING THE BLENDING TO TAKE PLACE.

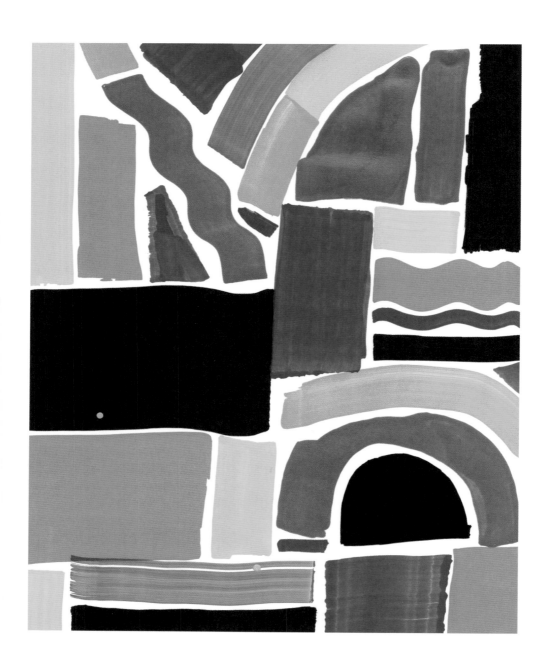

DRAW
HERE

You can achieve fast and bold results with thick markers. Both acrylic and ink ones are very fluid and easy to work with. Try making big modular compositions above, and watch their drying time because they take a bit longer to dry than average-size markers. Store them upside down to be sure they don't leak inside their caps.

TIP: MONTANA AND OTHER BRANDS SELL EMPTY "BIGGIE" MARKERS THAT YOU CAN FILL TO MAKE YOUR OWN UNIQUE COLORS. YOU CAN FILL THEM WITH LIQUID ACRYLIC INK OR ALCOHOL INKS FOR A PERMANENT EFFECT.

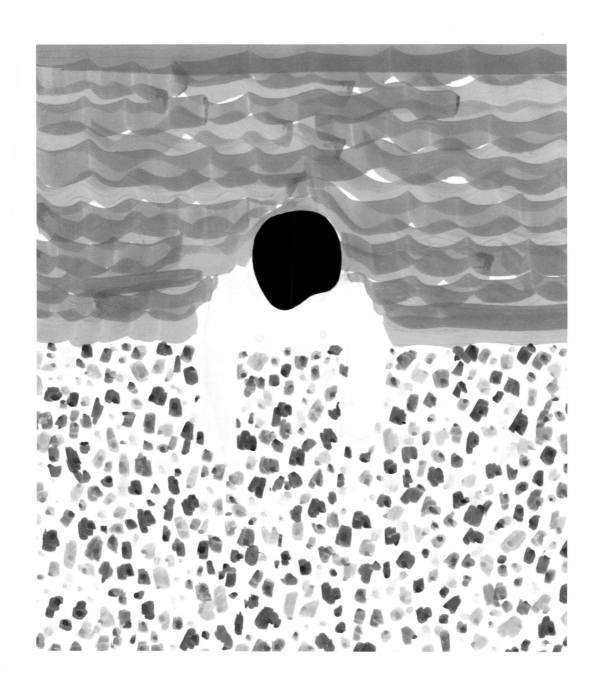

DRAW HERE

Your point of view can change your drawing immensely. For this exercise, try sketching something from above instead of in front of it. Be as detailed as you want but pay attention to how the shapes change depending on your point of view.

TIP: EXPERIMENT WITH ALCOHOL-BASED INK MARKERS, SUCH AS COPIC BRAND, WHICH I USED FOR THE SEA WAVES BECAUSE THEIR TIPS ARE LONG AND STURDY. FOR THE REST OF THE DRAWING, I USED BRUSH TIP MARKERS TO CAPTURE MOVEMENT BETTER.

OUTSIDE THE LINES

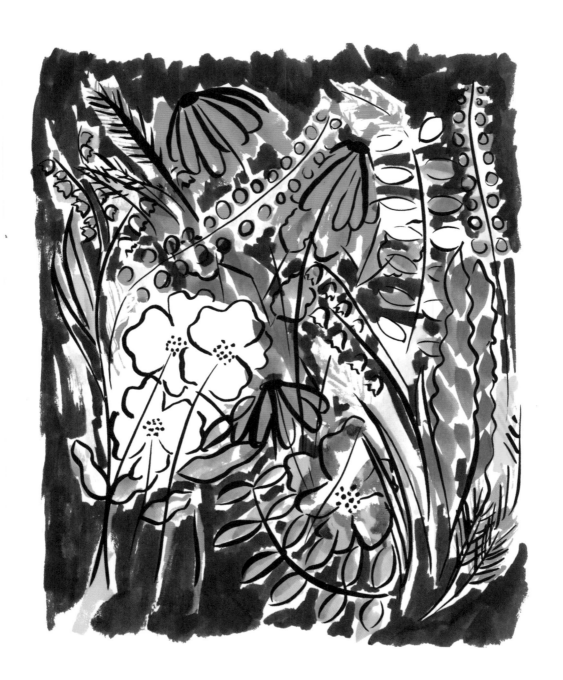

Outline your drawing softly with a 2B or similar pencil above. You can also use a light marker that will blend afterward when you are coloring. Don't add too many details at the first stage. Draw and define just by applying color freely and don't pay much attention to outlines and borders. It's fun and totally liberating to paint outside the lines!

TIP: YOU CAN ALSO TRY USING SATIN/GLOSSY PAPER FOR THE COLORS TO BE AS BRIGHT AS POSSIBLE AND TO PREVENT THE INK FROM BLEEDING WHEN YOU ARE MAKING YOUR MARKS. LOOK FOR COATED OR MARKER PAPER.

MEASURING

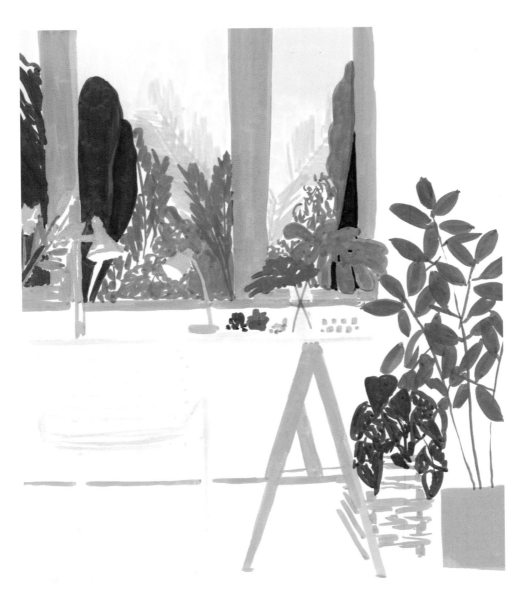

DRAW HERE

Choose a space that you like, such as your home, a café, or any other place. Start outlining it with a pencil. To calculate proportions, use the pencil you are drawing with as a reference. Extend your arm fully and align the pencil with a line of the object you want to measure. Place the tip of your thumb on the beginning of the line and the top of the marker on the end. Move your hand and compare this measure with other areas in the composition. Is the table twice as long as the plant beside it? Noticing and comparing will help you draw more accurately.

TIP: CLOSE ONE EYE TO MEASURE AND TRY TO BE IN THE SAME POSITION—HEAD, ARM, AND SO ON—EVERY TIME YOU MEASURE. BE SURE YOUR ELBOW IS ALWAYS LOCKED TO HAVE A CONSISTENT MEASUREMENT REFERENCE.

CHALK ON DARK

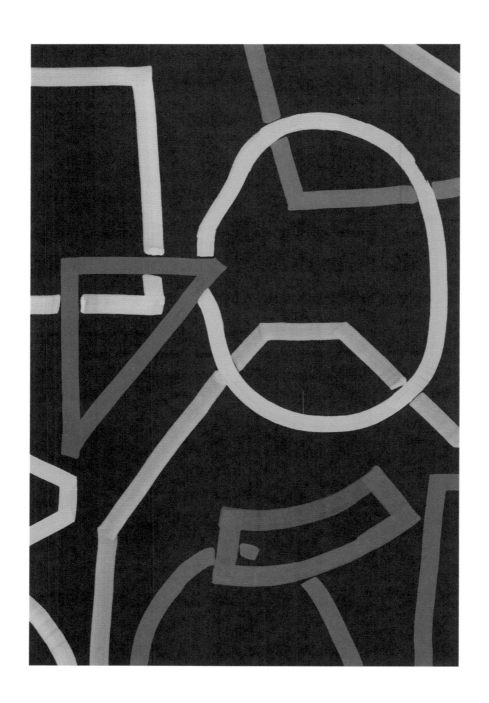

DRAW HERE

Chalk markers are an amazing invention. Their opaque matte results make me think of gouache whenever I see them. They're like the sharp cousin of gouache painting! For this exercise, we'll take advantage of their opacity by using them on top of a dark background (see tip below). Shake them well and draw slowly to make the ink as uniform as possible.

TIP: YOU CAN USE DARK PAPER FOR THIS EXERCISE, BUT IF YOU HAVE THE TIME, MAKE THE BACKGROUND YOURSELF BY APPLYING ACRYLIC PAINT OR SUMI INK DIRECTLY ABOVE OR ON ANOTHER SURFACE. THE COLOR WILL BE MUCH RICHER.

FOLD AND PAINT

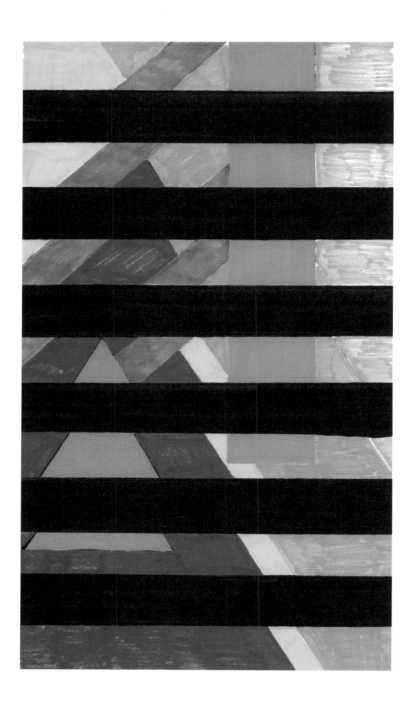

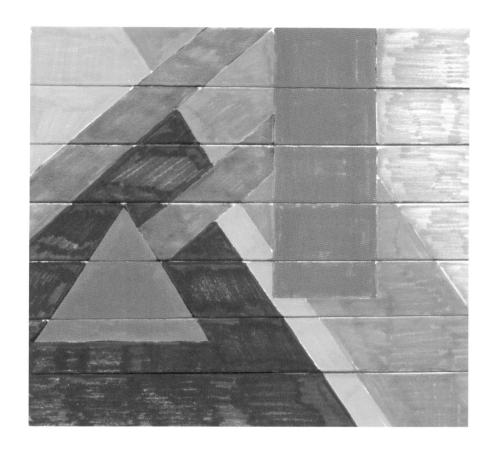

Measure and then draw equal-size bands on a piece of paper. Then fold it in a zigzag way. Keep it folded and draw something over that surface. Unfold the paper and color the blank areas. If you open it like an accordion, you'll be able to see the color drawing when looking from one angle and the black surface when looking from the opposite angle.

TIP: I PAINTED THE SPACES IN BETWEEN BLACK FOR YOU TO SEE THE FOLDS CLEARLY, BUT YOU CAN PAINT A DIFFERENT MOTIF IN THESE AREAS THAT CAN BE SEEN WHEN THE PAPER IS FOLDED THE OTHER WAY.

HATCH AND CROSSHATCH

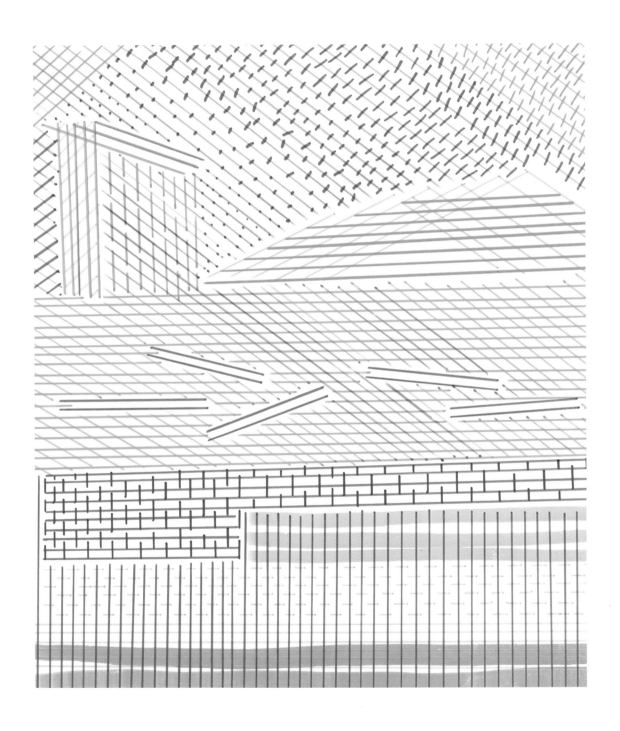

DRAW
HERE

Hatching and crosshatching can give depth and volume to a drawing but you can also use them in a more graphic way, as rhythmic textures. First, outline the basic structure of your composition, then start playing with overlapping lines to define the shapes. Have fun trying different colors and angles.

TIP: TO FOCUS ON THE TEXTURE AND NOT BE DISTRACTED BY COMPOSITION, YOU CAN ALSO PLACE TRACING PAPER ON TOP OF ANOTHER DRAWING OR PHOTOGRAPH AND JUST HATCH AND CROSSHATCH TO DEFINE THE DIFFERENT AREAS.

HAIRSTYLES

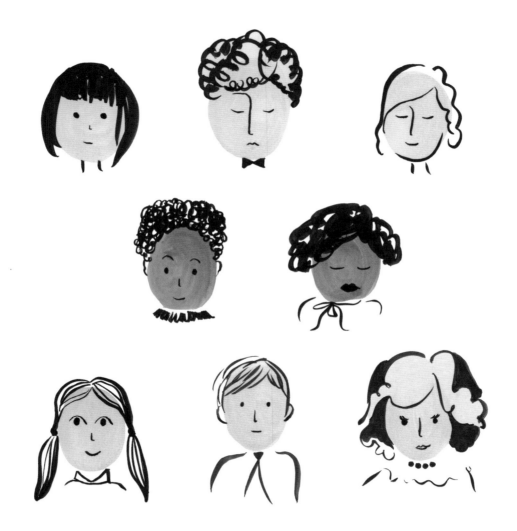

DRAW HERE

Make a few rounded shapes that look like heads. Let them dry and get ready for the fun part. Picture different characters with different personalities. Imagine their features and hairstyles. Try to represent them with simple sketches and as few strokes as possible. A whole haircut can be represented with just one or two marks.

TIP: TRY DIFFERENT STROKES FOR DIFFERENT HAIRSTYLES, SUCH AS STIPPLING (SEE PAGE 54) FOR SHORT HAIR, SCRIBBLING FOR CURLY HAIR, FLUID STROKES FOR WAVY HAIR, DELICATE ONES FOR THIN, STRAIGHT HAIR, AND SO ON.

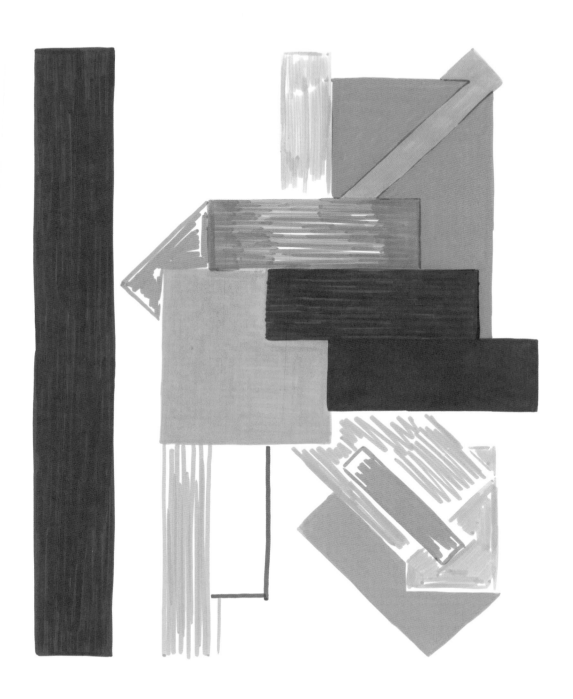

DRAW HERE

Restriction sometimes is good for creativity. For this exercise, choose just one shape and play around with it to make a composition. It can be any shape; the important thing is to explore the possibilities that it offers. Rotate, scale, mirror, repeat, and add texture—these are just a few of the things you can do with the shape you choose.

TIP: YOU DON'T HAVE TO STAY ABSTRACT FOR THIS EXERCISE. WITH A SIMPLE SHAPE REPEATED OVER AND OVER YOU CAN CREATE ALL KINDS OF MOTIFS, FROM LANDSCAPES TO PORTRAITS. JUST EXPLORE THE IDEA AND YOU'LL SEE.

NEGATIVE SPACE

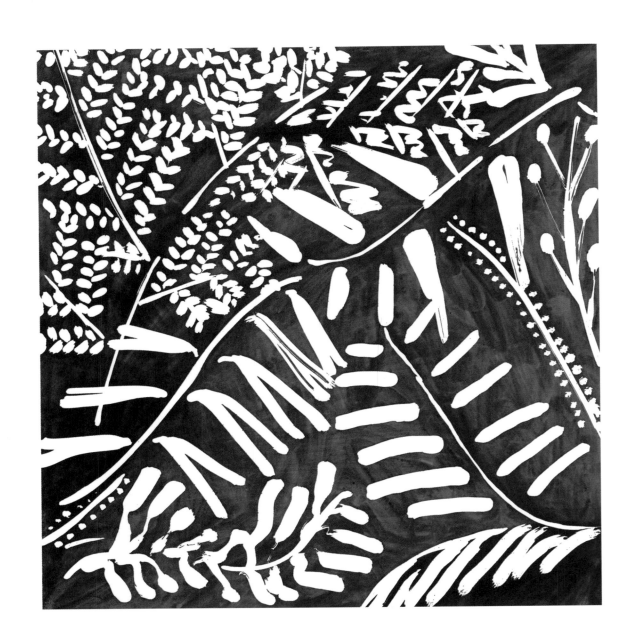

Let's focus on negative space for this exercise and mask areas instead of applying color to them. You can do this with frisket—see page 50 for tips—or masking tape. For the masking-tape method, cover an area of your cutting mat with tape, overlapping it in places. Use a craft knife to cut shapes out of the tape surface you just made. Arrange the "stickers" you just cut on top of coated paper and color with markers all over the paper. When dry, carefully remove the masking-tape stickers to reveal the clean shapes.

TIP: FEEL FREE TO ADD TEXTURES TO THE PREVIOUSLY MASKED AREAS SO THAT THEY STAND OUT EVEN MORE. TRY ROLLING YOUR MARKER, PLACING IT AT DIFFERENT ANGLES, OR STIPPLING TO ACHIEVE DIFFERENT MARKS AND STROKES.

OUTLINES AND TEXTURES

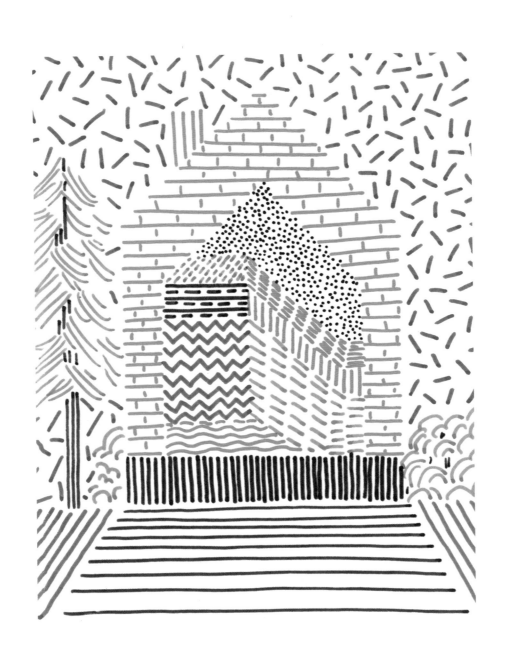

Have you ever noticed that when a building is partially demolished, you can still see the separate rooms inside—their outlines, the tiles in the bathroom, and the wallpaper in a bedroom? For this exercise, draw the outline of a house and its rooms. Then add patterns and textures to represent the different areas.

TIP: OUTLINE THE DRAWING WITH A RULER AND PENCIL FIRST TO KEEP THINGS CLEAN. IF YOU WANT THE DRAWING TO LOOK MORE GRAPHIC AND ARCHITECTURAL, CHOOSE MUTED TONES OR GO BLACK AND WHITE.

MODULAR PORTRAIT

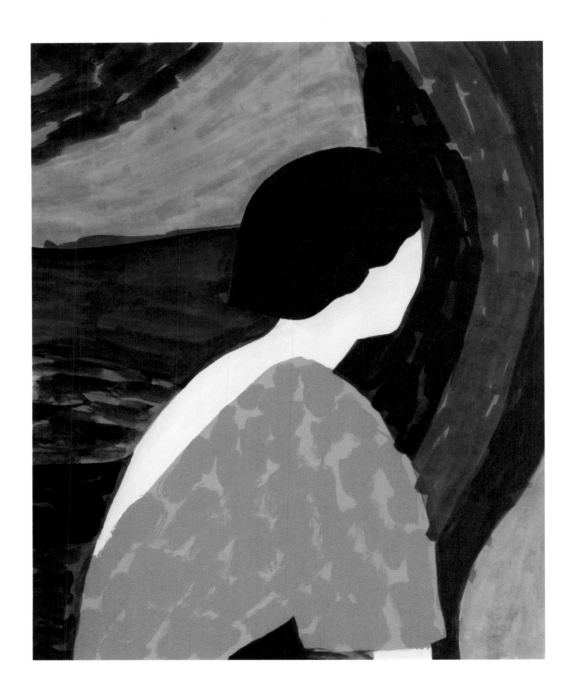

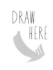
DRAW HERE

Synthesize a portrait to its minimum expression. Just draw its contours, ignore features, and focus on the most relevant shapes. When you have three or four areas, divide them into different shapes to create modules that can be colored in various shades. This way, you can compensate for the simplicity of shapes with the complexity of color.

TIP: SOMETIMES IT'S DIFFICULT TO COME UP WITH A SYNTHESIZED DRAWING ON THE FIRST TRY. IT'S USEFUL TO MAKE SEVERAL BASIC SKETCHES AND SIMPLIFY ALONG THE WAY TO CAPTURE THE ESSENCE.

IMPOSSIBLE SHAPE

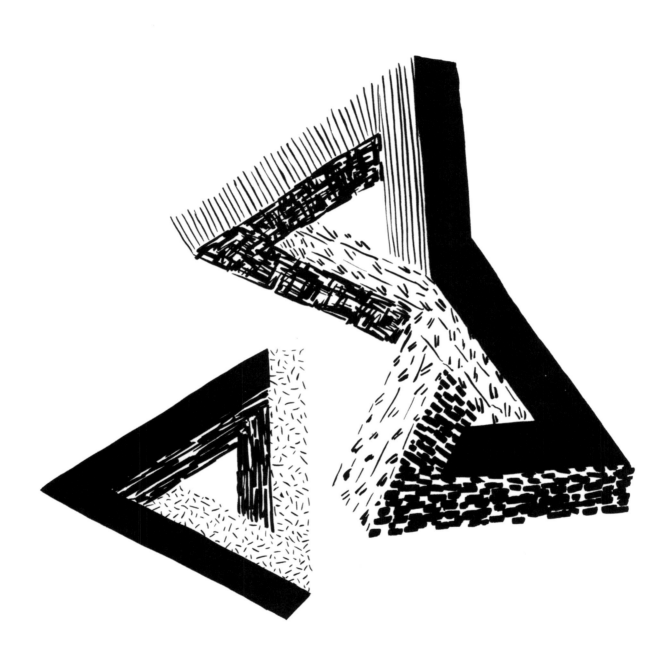

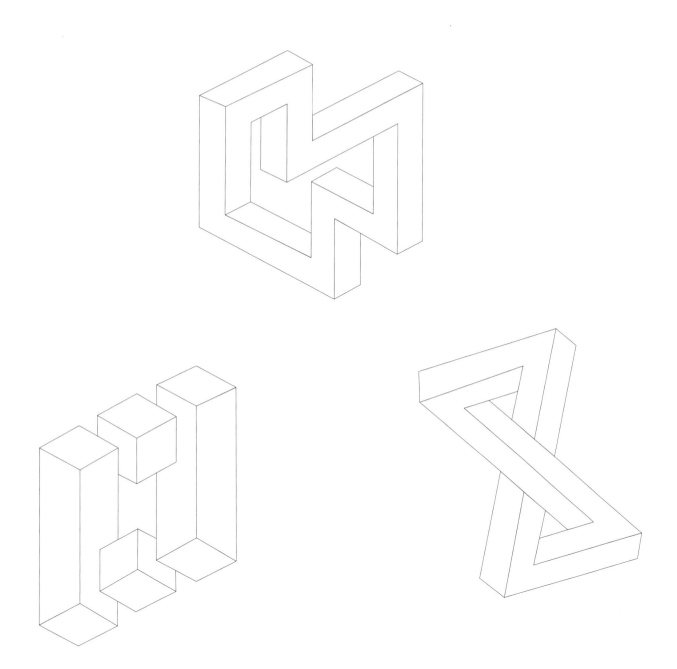

Let's make an impossible object outlining a simple geometric shape with a pencil. Add parallel lines to create the illusion of thickness for each of the strokes. Now let's mess up perspective for a bit and let's bring to the front parts of the bars that should be on the back and vice versa. Redraw and adjust until you are happy with the result and color.

TIP: THE ONES I SKETCHED ON THE OPPOSITE PAGE ARE BASED ON THE PENROSE TRIANGLE BUT FEEL FREE TO EXPERIMENT AND COME UP WITH DIFFERENT ONES. YOU CAN ALSO STUDY AND TRY ANY OF THE ONES OUTLINED ABOVE.

SURREAL MANDALA

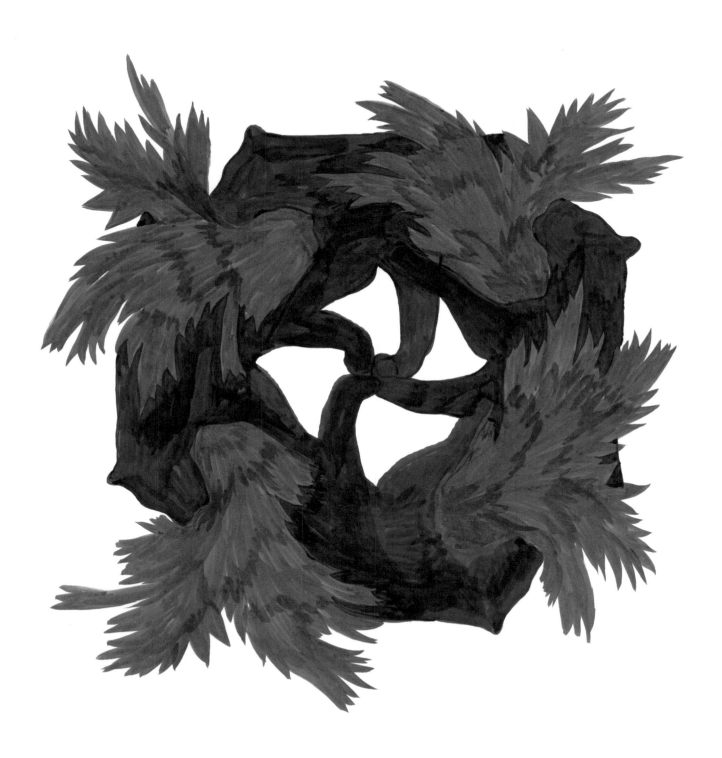

DRAW HERE

Draw and cut two different shapes out of cardstock. Move and rotate them slightly while tracing their contours above with a pencil so that their repetition forms a circle. Color the areas until you get your own surreal mandala. You can also try other shapes instead of a circle. A pentagon, heptagon, or star could also work well as the basis.

TIP: TO HELP YOU PLACE AND ARRANGE THE STENCILS, DRAW A CIRCLE IN THE MIDDLE OF THE PAGE OR TRACE TWO CROSSING LINES AS A GUIDE. THIS WAY, YOUR DRAWING WILL STAY ALIGNED TO THE CENTER.

MIXED TECHNIQUES

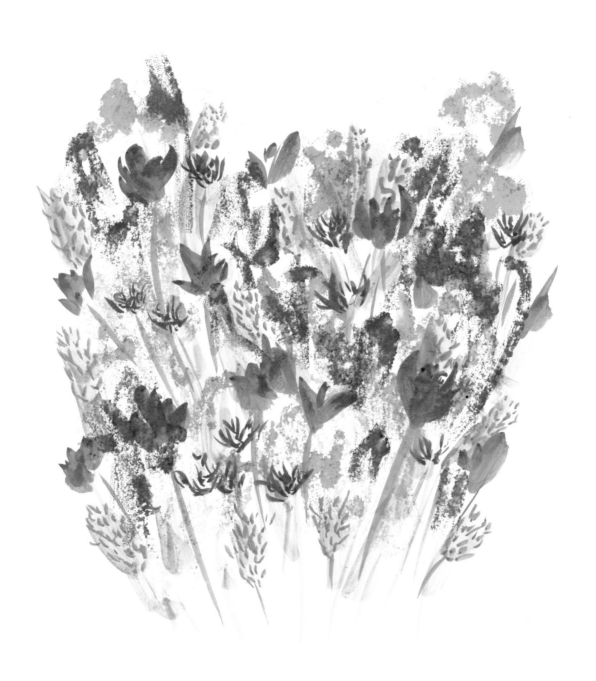

DRAW
HERE

For this exercise, use some of the techniques that we already covered in this book and create a picture exploring the finishes that each of the techniques can give you. For the artwork on the opposite page, I used monotyping, stippling, making "wild marks," and using the blender marker. The combinations of techniques are endless, so have fun!

TIP: YOU DON'T HAVE TO STICK TO THE TECHNIQUES IN THIS BOOK. THERE ARE MORE IDEAS IN THE OTHER PLAYBOOKS (SEE THE BACK COVER OF THIS BOOK), BUT FEEL FREE TO EXPERIMENT AND COME UP WITH YOUR OWN TECHNIQUES!

ABOUT THE ARTIST

Describing herself as a "professional enthusiast," Ana Montiel is quite a Renaissance woman. Her many passions and interests keep piling up as the years pass. Her influences include utopian architecture, eastern philosophy, antique botanical illustration, astronomy, quantum physics, the Bauhaus movement, and the Arts and Crafts movement.

With an education in fine arts, she has continued to learn new skills, enough to set up a design studio in Barcelona; a wallpaper brand whose first product, "Topo Azul," was featured in the *New York Times*; a solid art direction and illustration career working on commissions for the likes of Anthropologie, Nina Ricci, and Clinique; exhibitions of her work in many countries; write two art guidebooks, *The Paintbrush Playbook* and *The Pencil Playbook*; and live a life full of experiments that often become more than that.

Ana spends her time painting, making pottery, cooking, designing all kinds of things, learning permaculture and ethnobotany, which she puts into practice in her own garden, and so on. "There's always something exciting to learn and try," she says.

Through Ana's latest ongoing art project, "Visual Mantras," she explores repetition as a meditation/trance and has developed a series of absorbing and richly colored geometries that bring up the cyclical rhythm of existence.

After spending most of her life in Europe, Ana decided to embark on a spiritual and artistic quest and moved to México.

Quarto is the authority on a wide range of topics.

Quarto educates, entertains and enriches the lives of
our readers—enthusiasts and lovers of hands-on living.

www.QuartoKnows.com

First published in the United States of America in 2016 by
Quarry Books, an imprint of
Quarto Publishing Group USA Inc.
100 Cummings Center
Suite 406-L
Beverly, Massachusetts 01915-6101
Telephone: (978) 282-9590
Fax: (978) 283-2742
QuartoKnows.com
Visit our blogs at QuartoKnows.com

10 9 8 7 6 5 4 3 2 1

ISBN: 978-1-63159-125-9
eISBN: 978-1-63159-190-7

Library of Congress Cataloging-in-Publication Data available.

Cover, design, and text: Ana Montiel and Tea Time Studio

Printed in China